Coloring into Serenity Mandalas

Hand Drawn Designs for Coloring

Jody Cooke

BALBOA.
PRESS

A DIVISION OF HAY HOUSE

Balboa Press books may be ordered through booksellers or by contacting:

Balboa Press
A Division of Hay House
1663 Liberty Drive
Bloomington, IN 47403
www.balboapress.com
1 (877) 407-4847

Because of the dynamic nature of the Internet, any web addresses or links contained in this
book may have changed since publication and may no longer be valid. The views expressed
in this work are solely those of the author and do not necessarily reflect the views of
the publisher, and the publisher hereby disclaims any responsibility for them.

The author of this book does not dispense medical advice or prescribe the use of any technique as a form of
treatment for physical, emotional, or medical problems without the advice of a physician, either directly or
indirectly. The intent of the author is only to offer information of a general nature to help you in your quest
for emotional and spiritual well-being. In the event you use any of the information in this book for yourself,
which is your constitutional right, the author and the publisher assume no responsibility for your actions.

Any people depicted in stock imagery provided by Thinkstock are models,
and such images are being used for illustrative purposes only.
Certain stock imagery © Thinkstock.

ISBN: 978-1-5043-7664-8 (sc)

Print information available on the last page.

Balboa Press rev. date: 03/20/2017

What is a Mandala?

A mandala is a sacred space, often a circle which reveals some inner truth about you or the world around you. In Sanskrit mandala means both circle and center, implying that it represents both the visible world outside of us (the circle - whole world) and the invisible one deep inside our minds and bodies (the center - healing circle).

From Native American and Tibetan sandpaintings to Gothic rose windows and Hindu yantras, mandalas are used as symbols for meditation, protection and healing.

Clare Goodwin

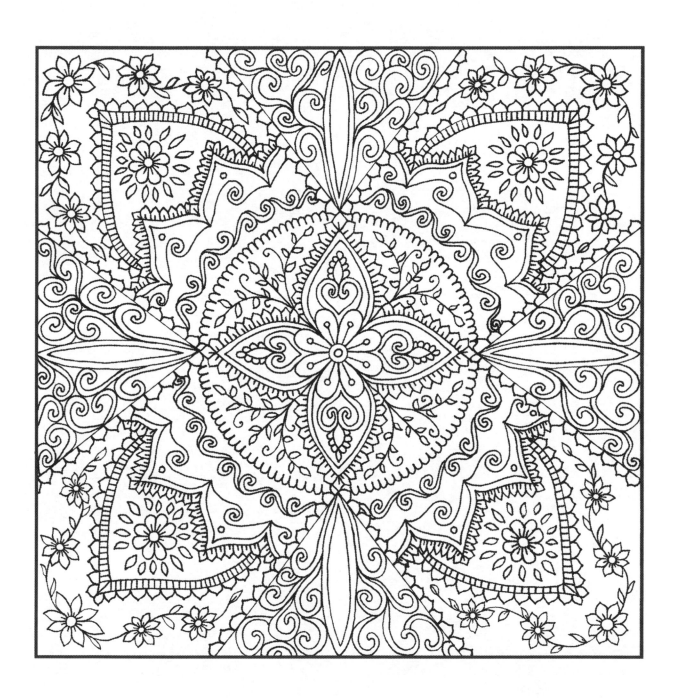

Mandala 01-29-15

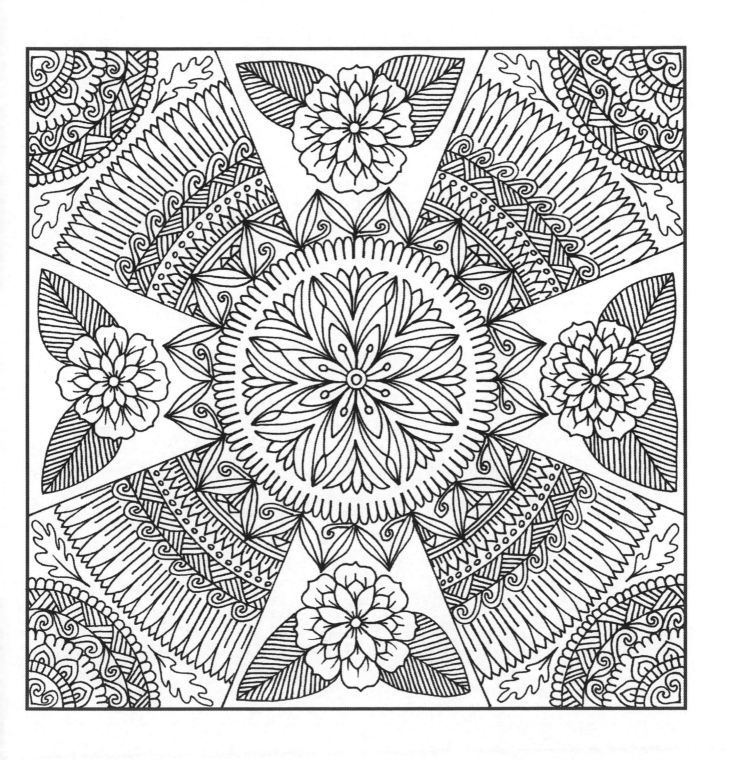

Mandala 03-17-15

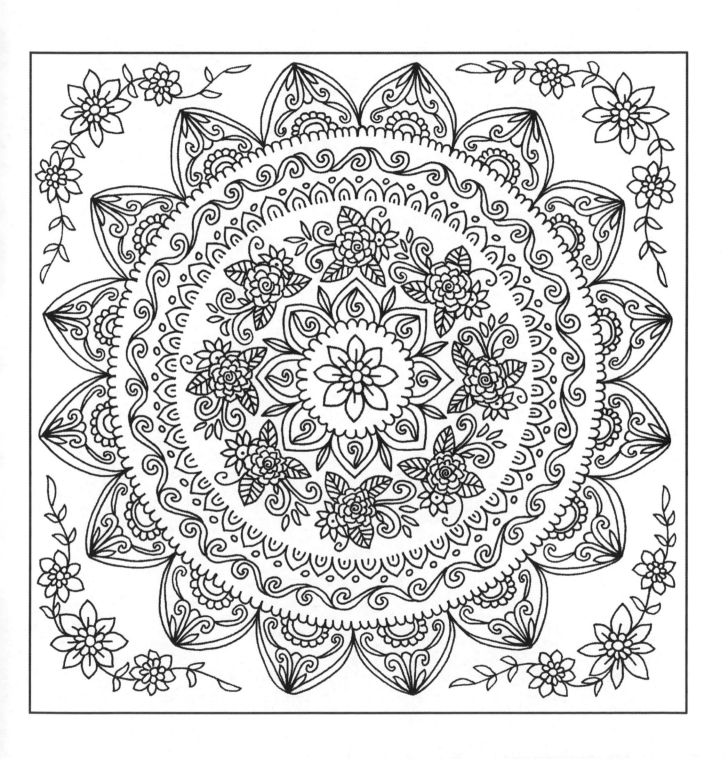

Mandala 10-15-15

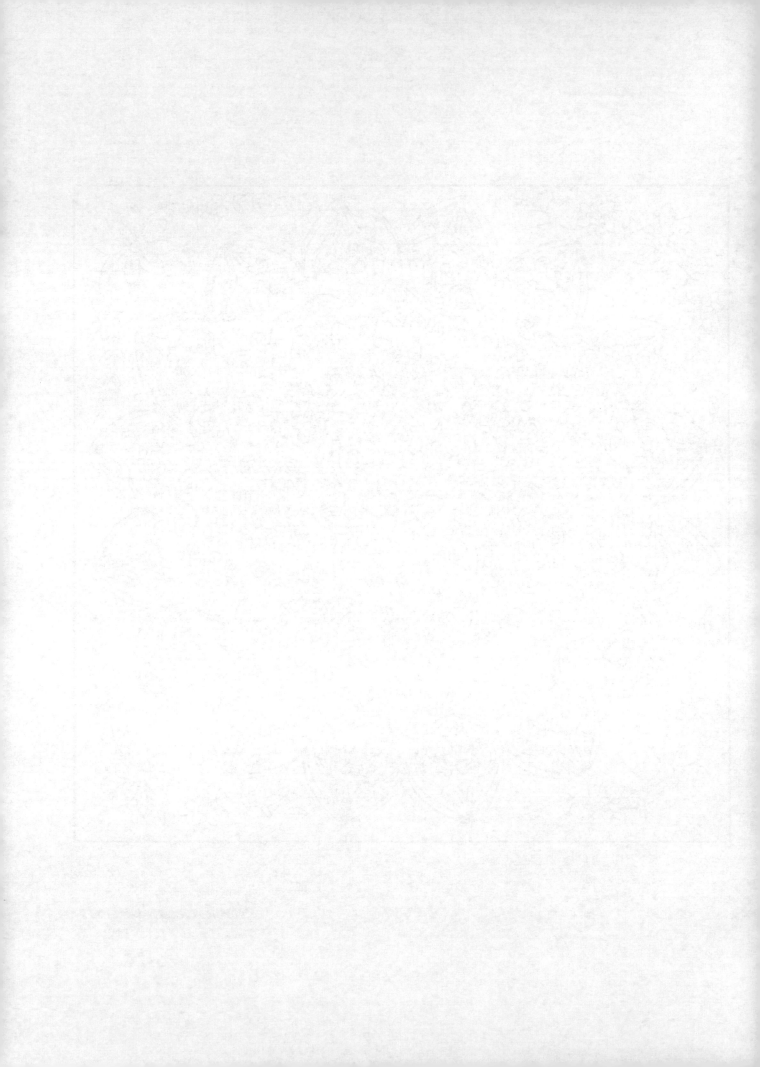

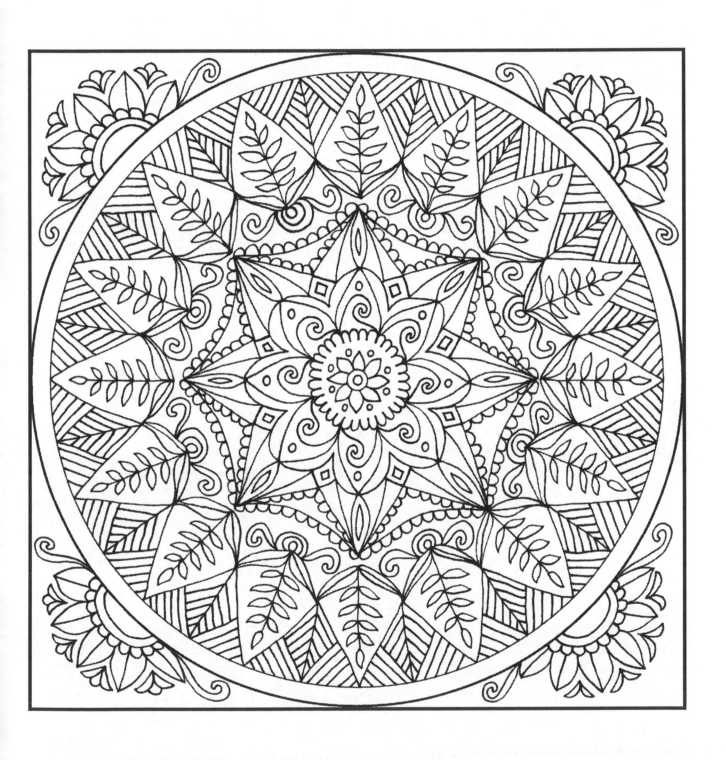

Mandala 01-10-16

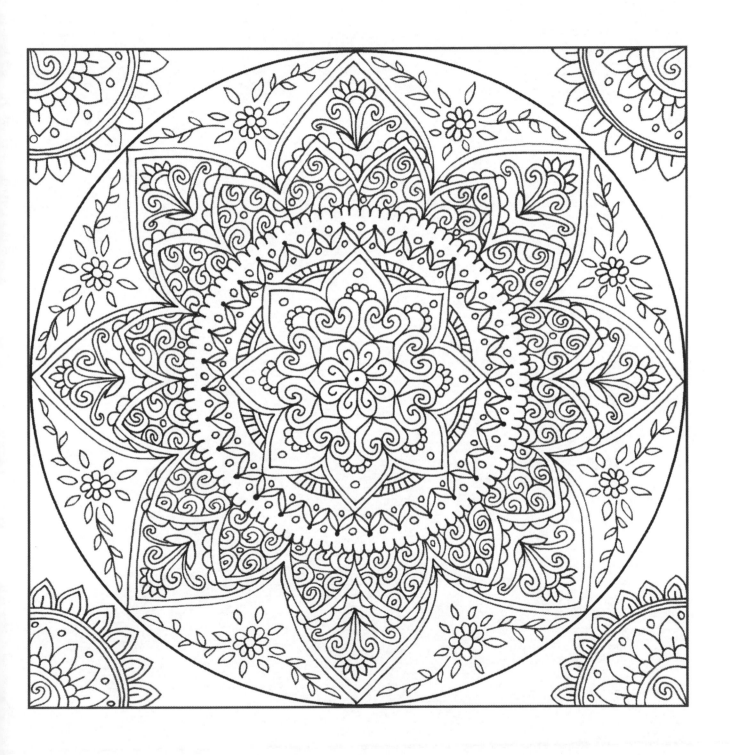

Mandala 01-19-16

Mandala 01-20-16

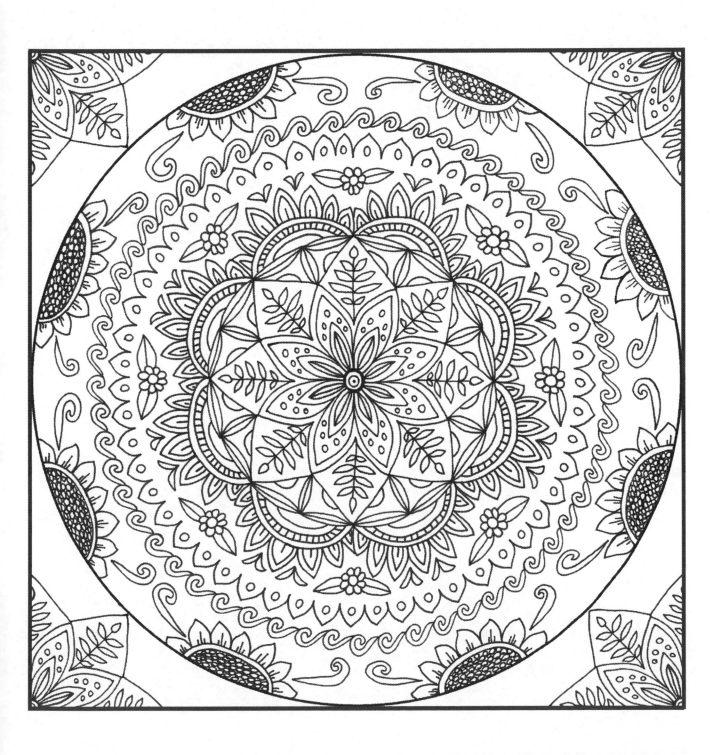

Mandala 01-25-16

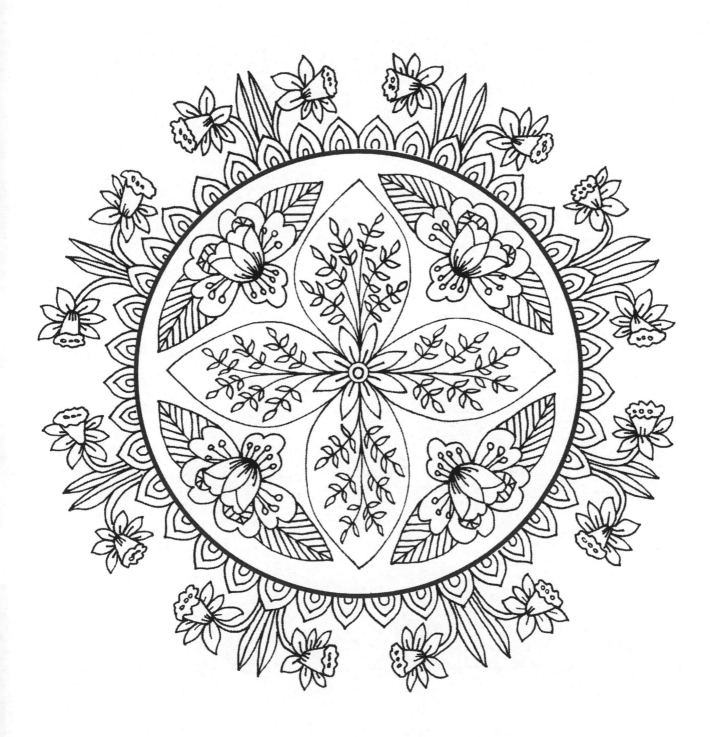

Mandala 01-31-16

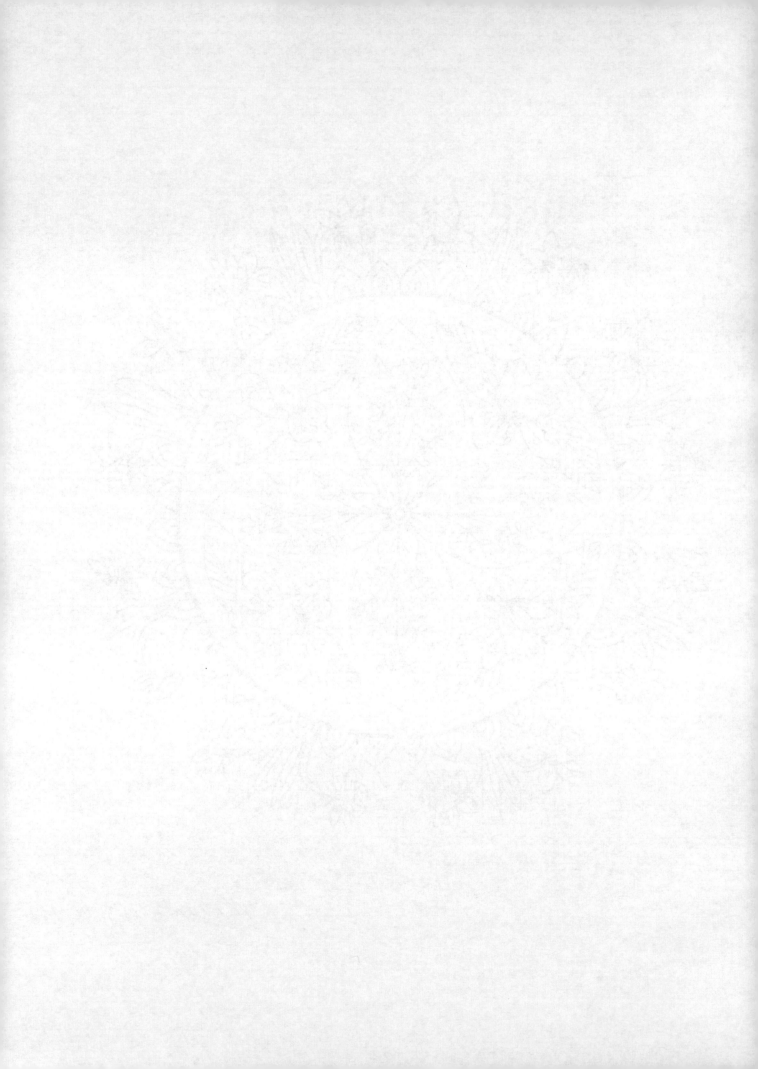

Mandala 02-03-16

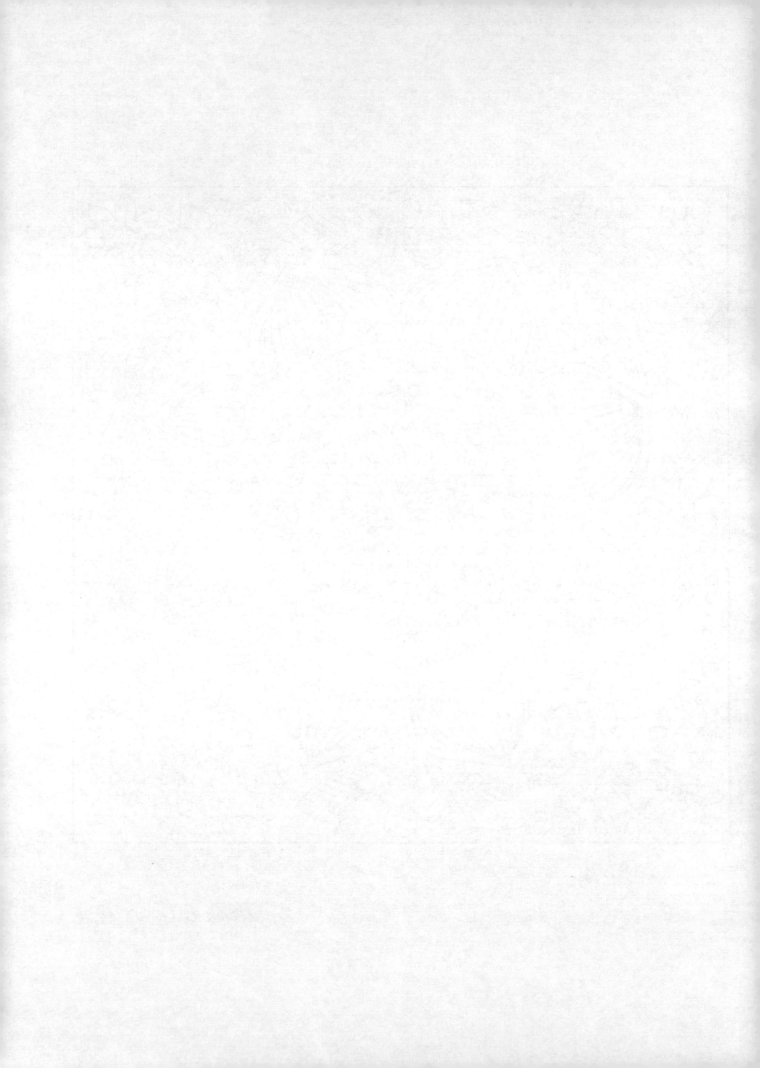

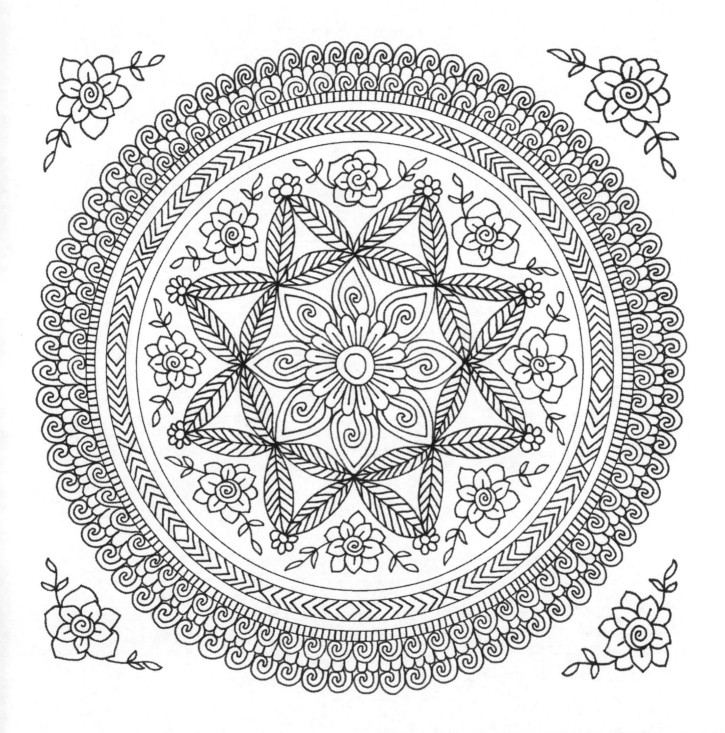

Mandala 02-08-16

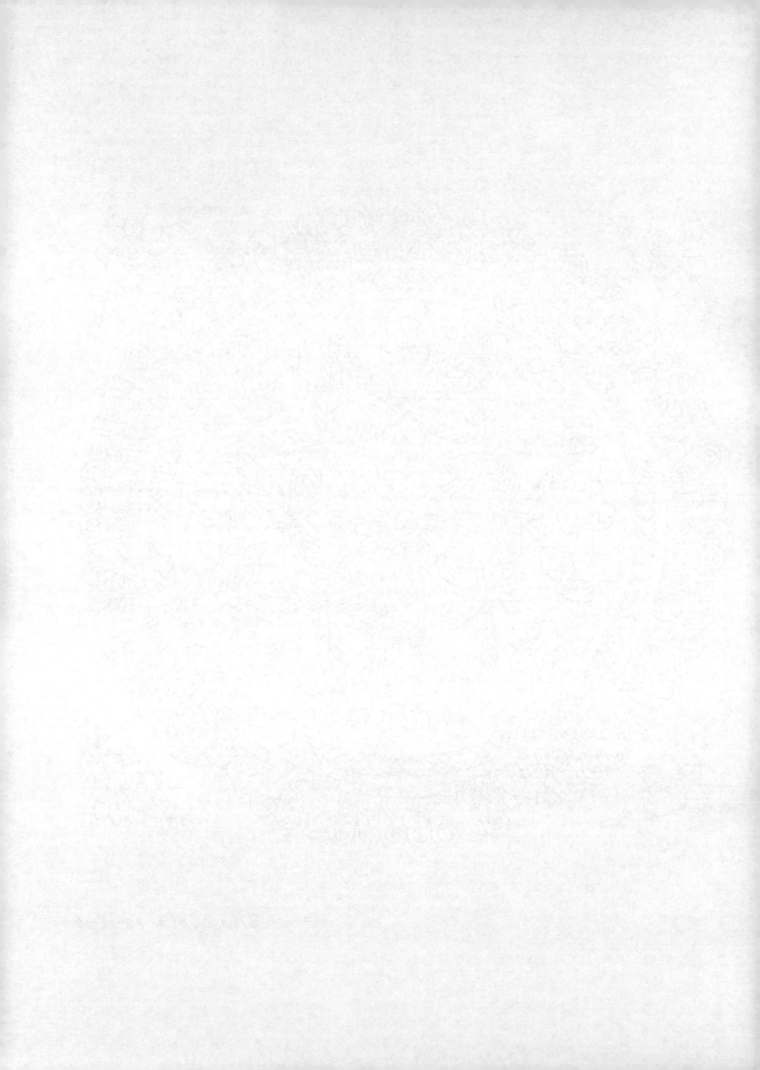

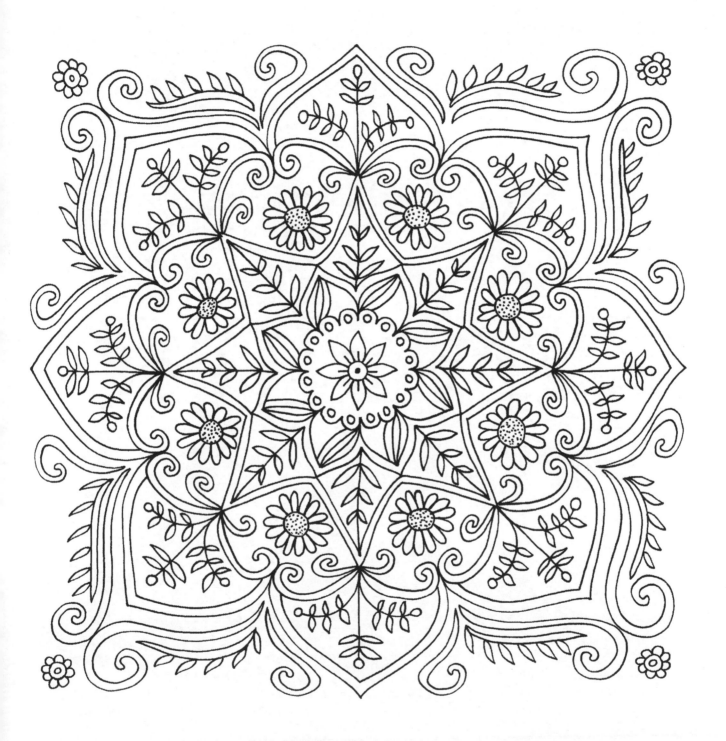

Mandala 02-14-16

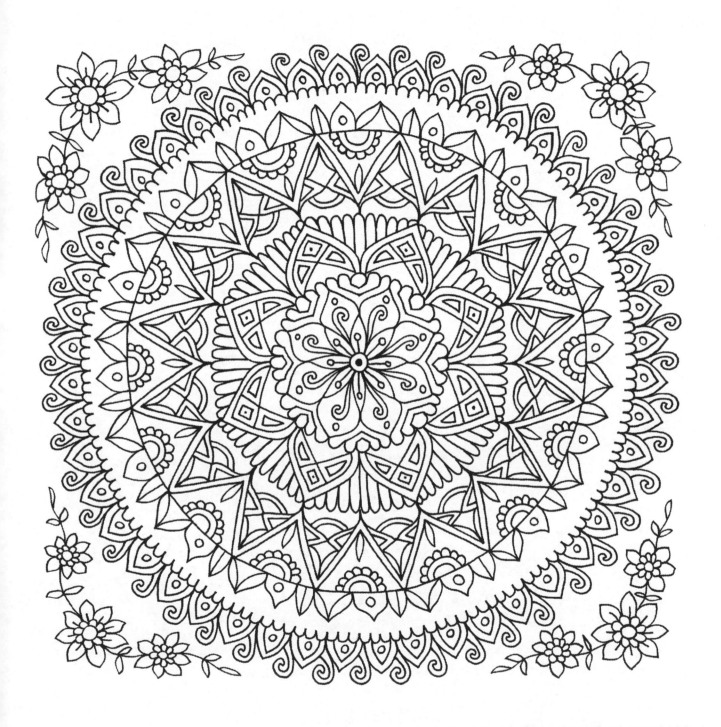

Mandala 02-19-16

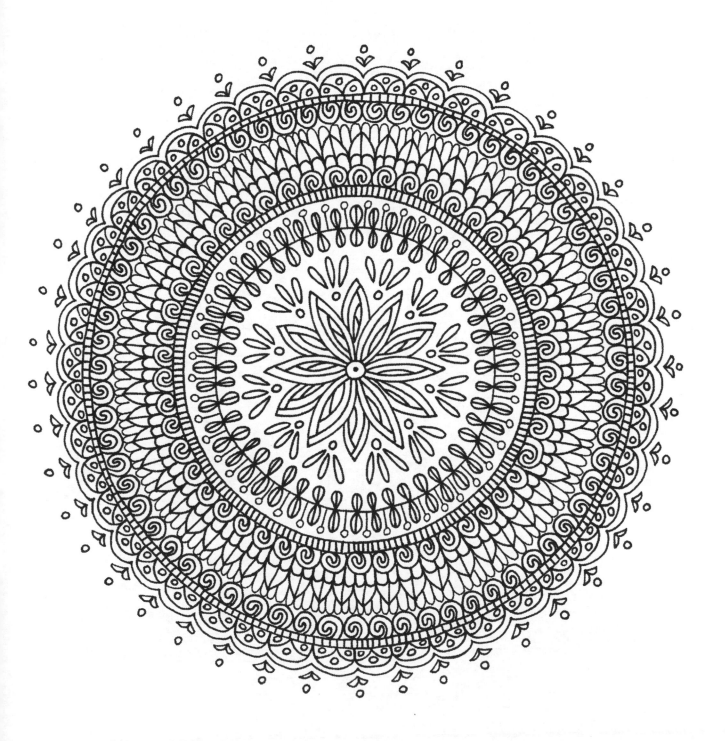

Mandala 02-25-16

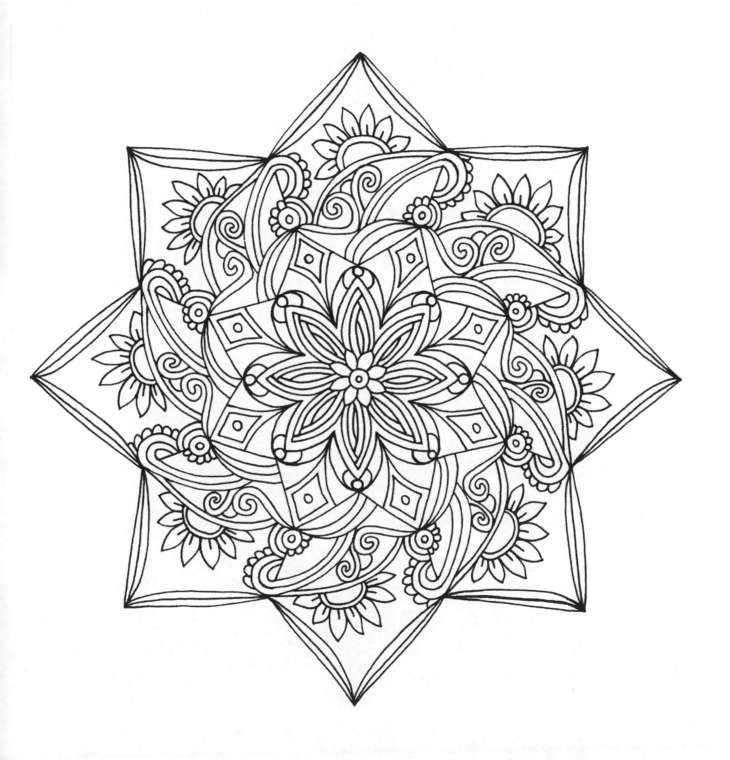

Mandala 02-26-16

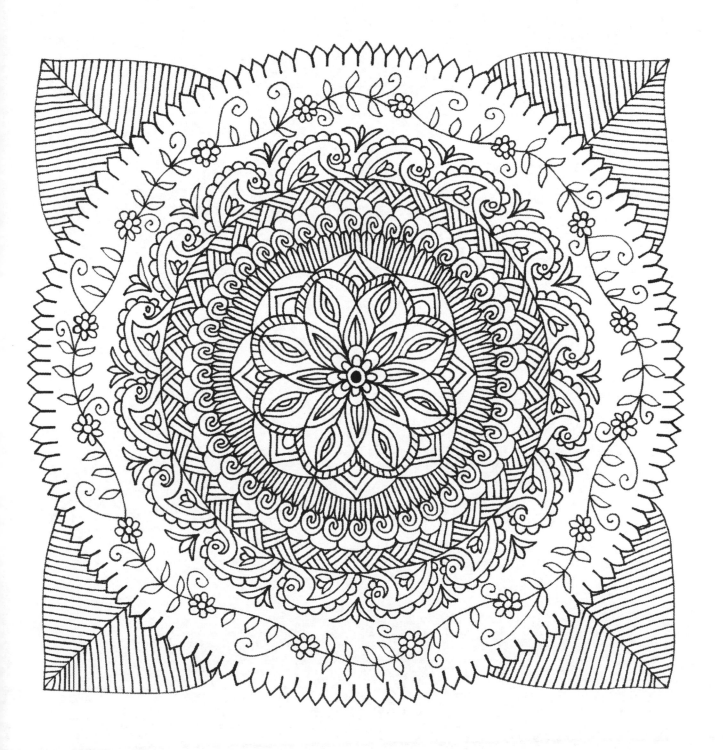

Mandala 02-28-16

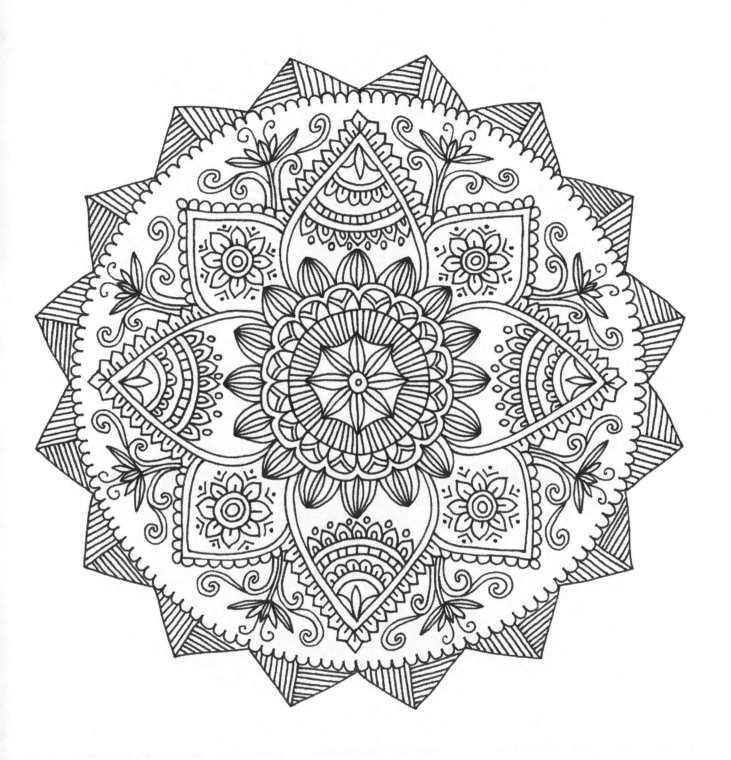

Mandala 03-10-16

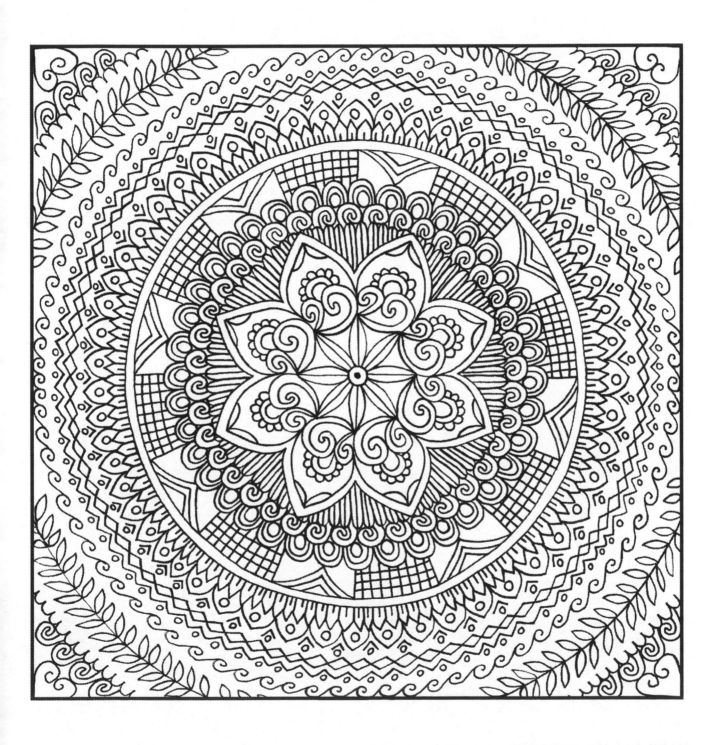

Mandala 03-14-16

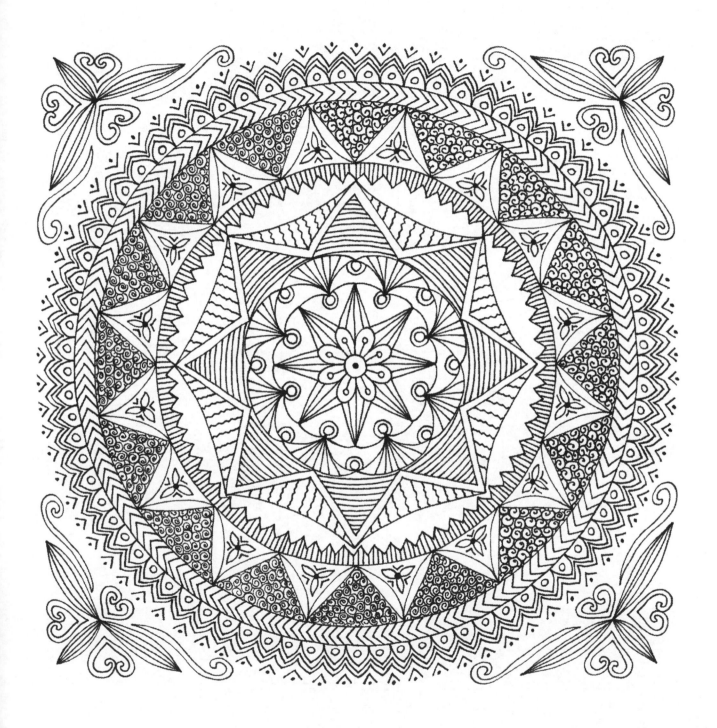

Mandala 03-16-16

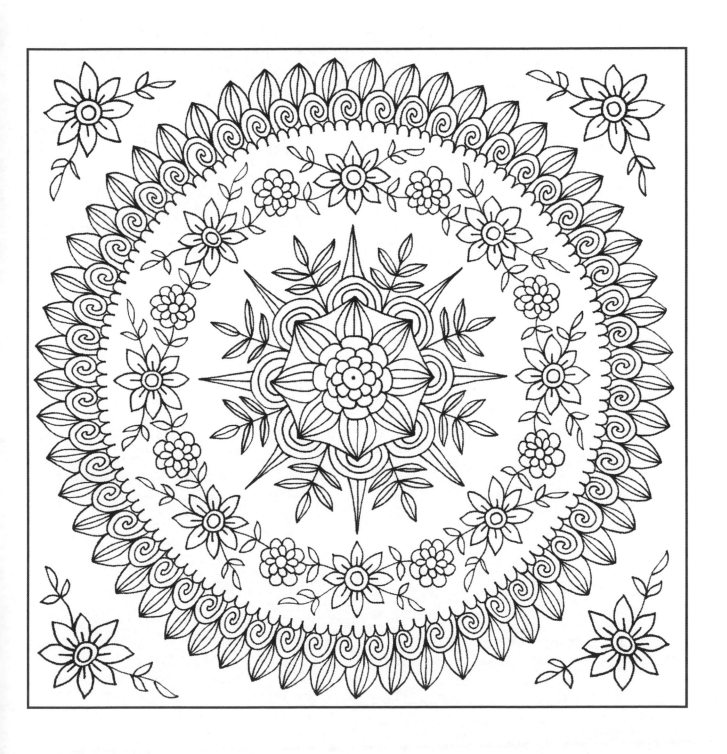

Mandala 03-19-16

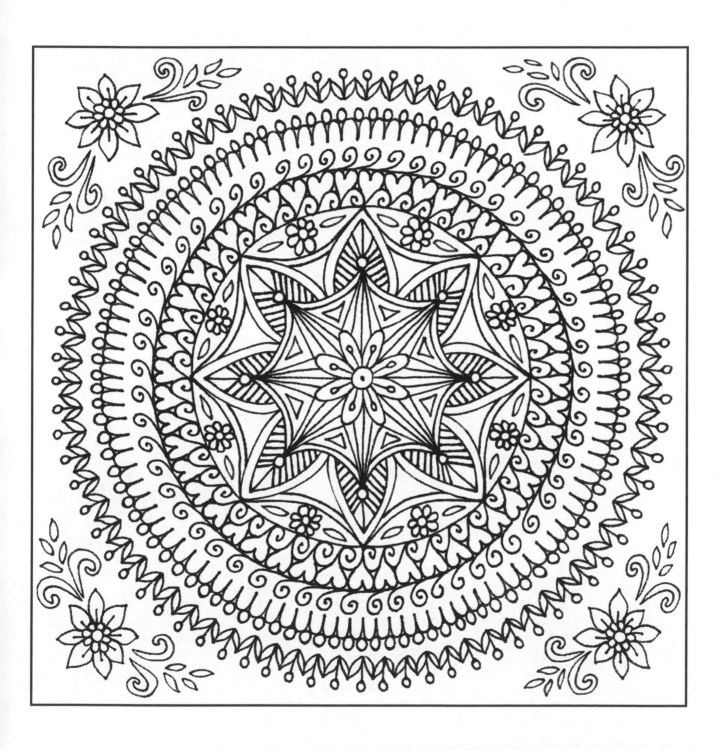

Mandala 03-20-16

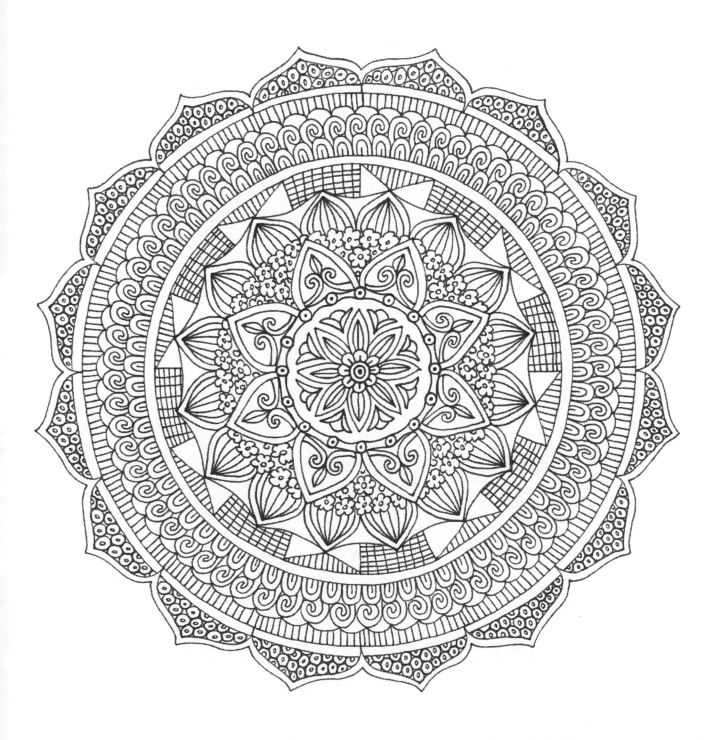

Mandala 03-21-16

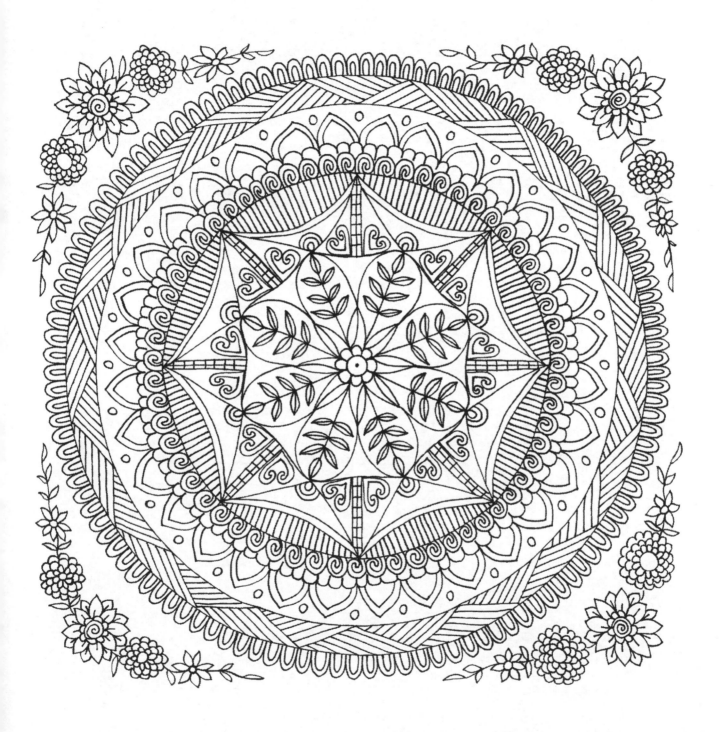

Mandala 03-28-16

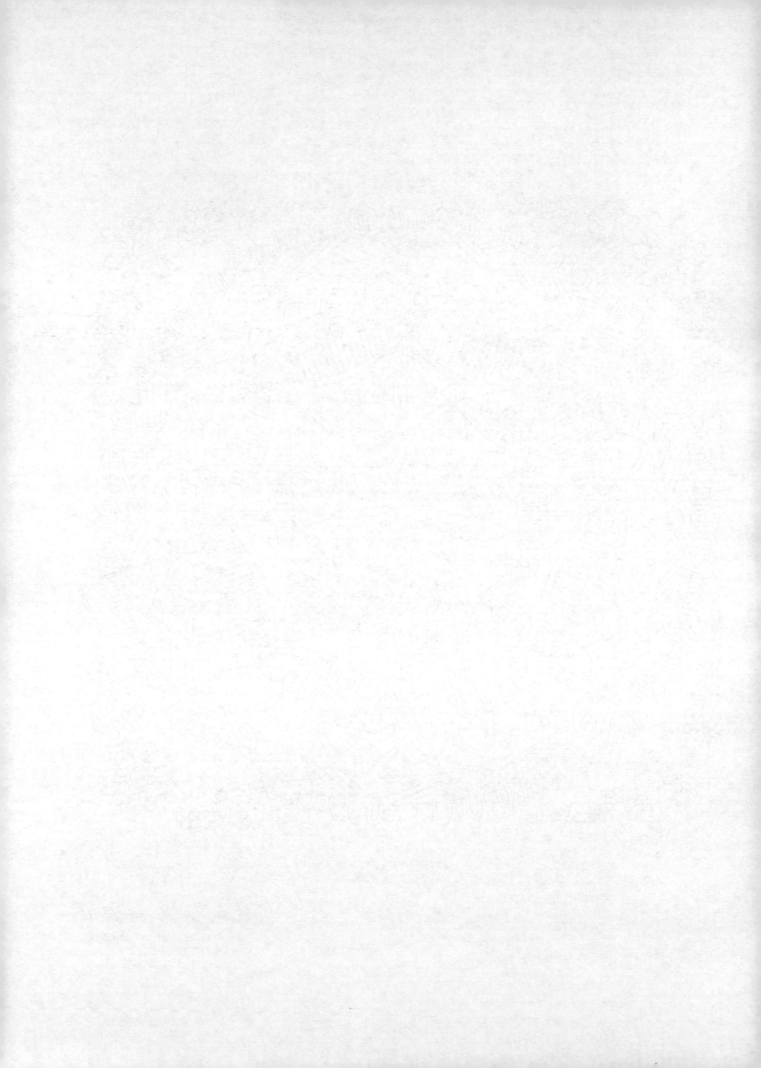

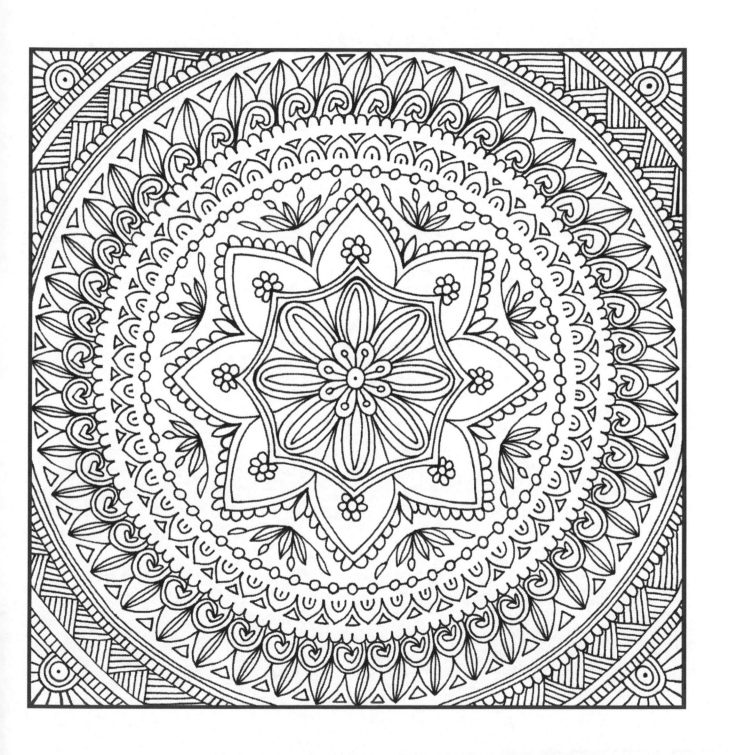

Mandala 04-02-16

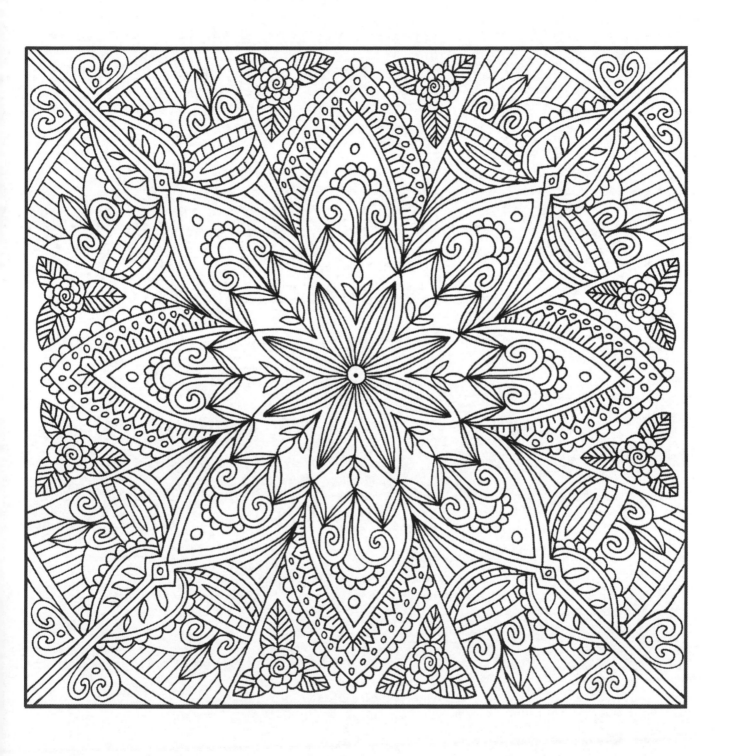

Mandala 04-04-16

Mandala 04-05-16

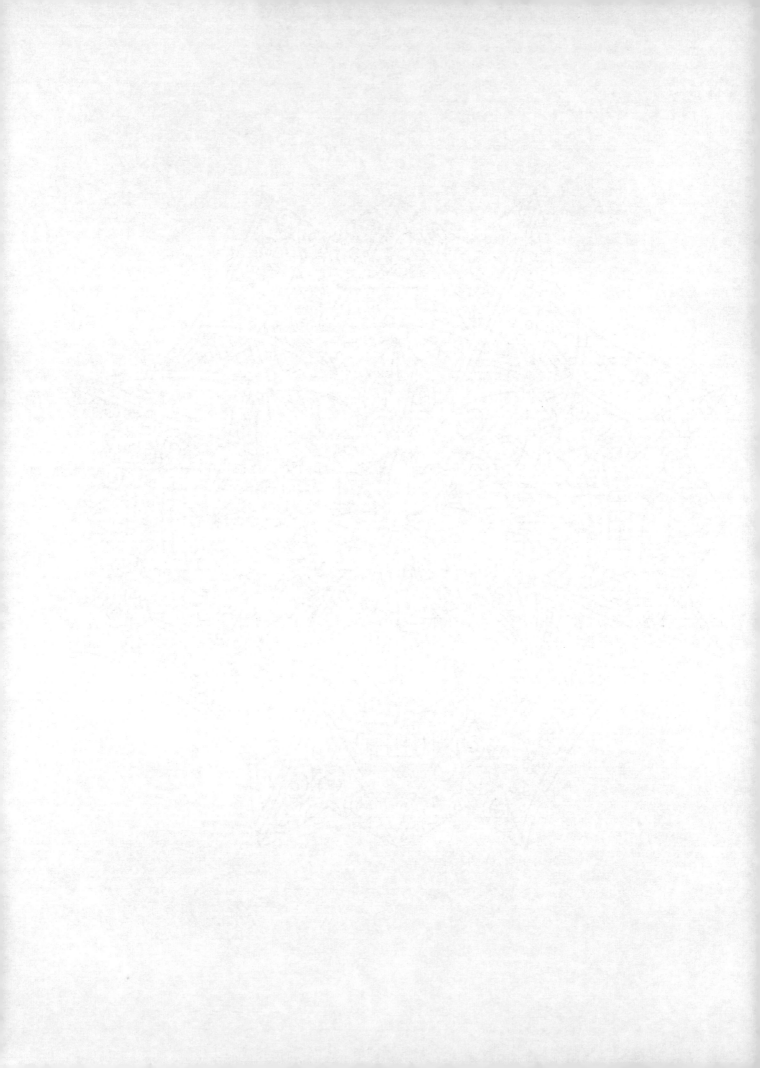

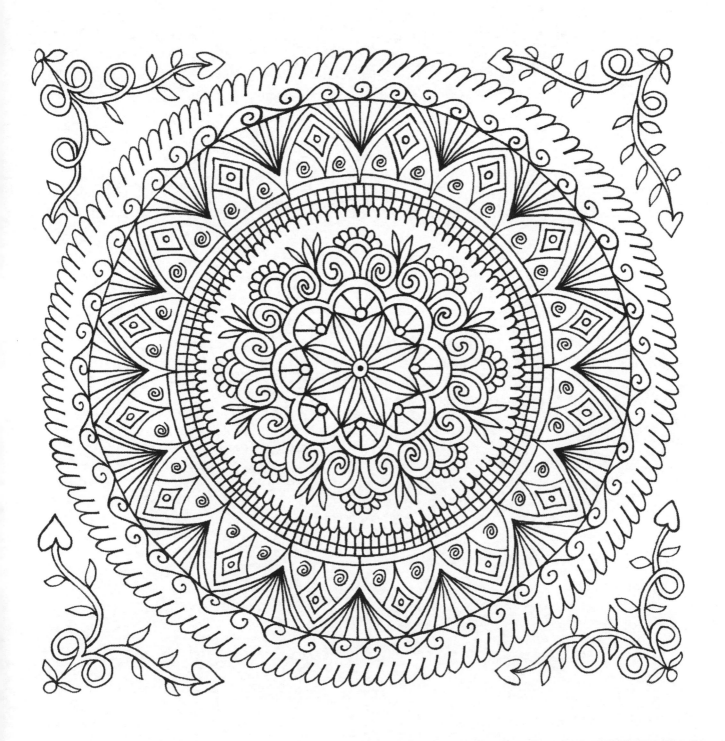

Mandala 04-26-16

Mandala 05-15-16

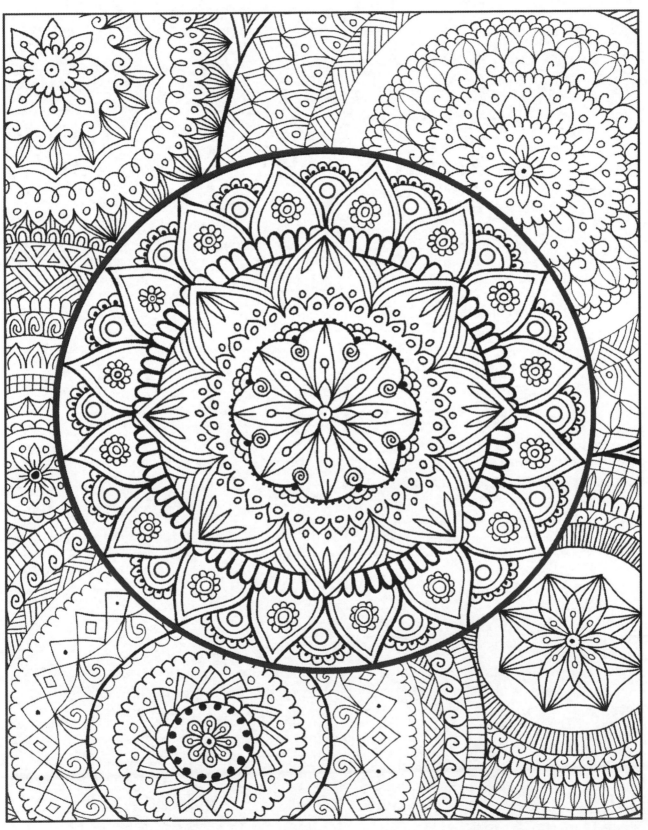

Mandala 05-20-16

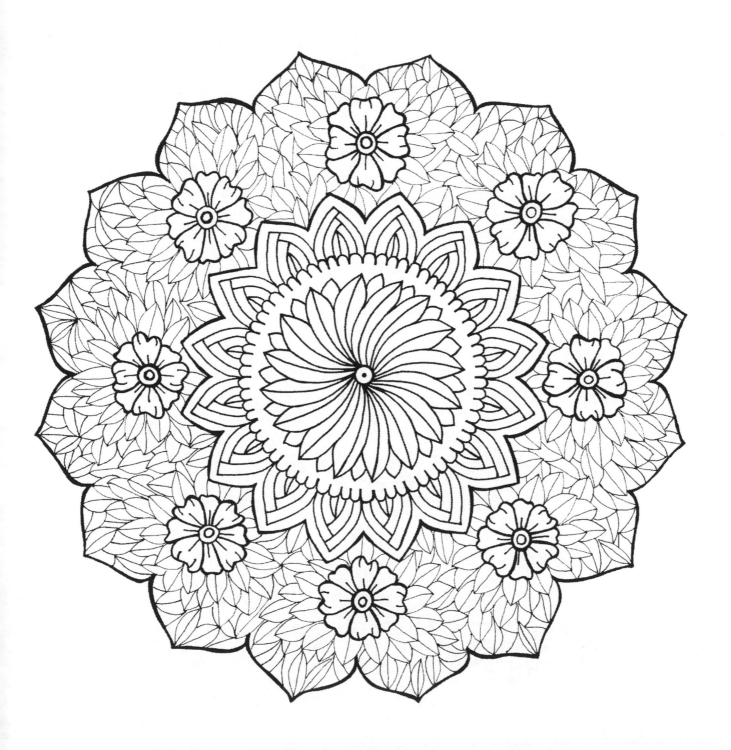

Mandala 05-21-16

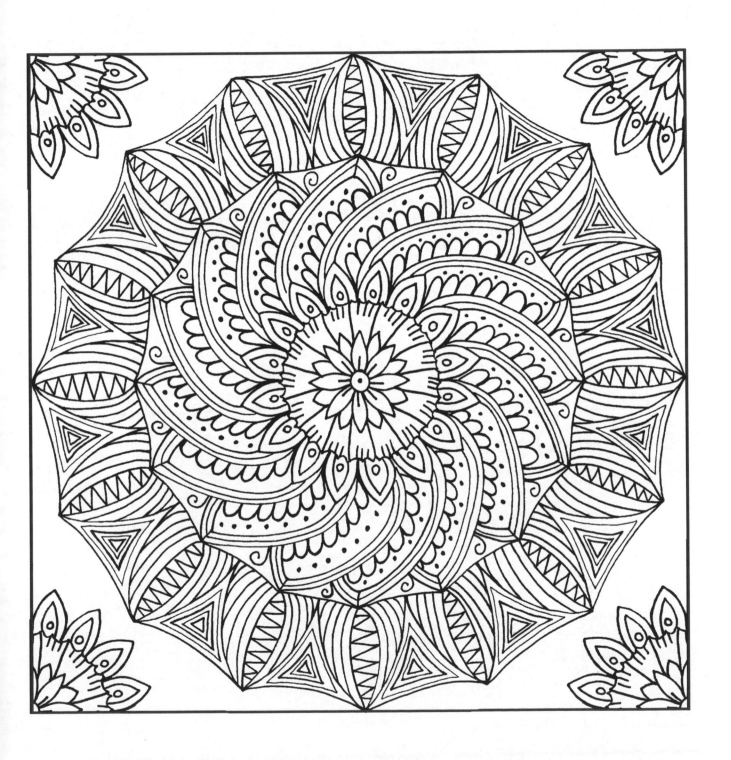

Mandala 05-23-16

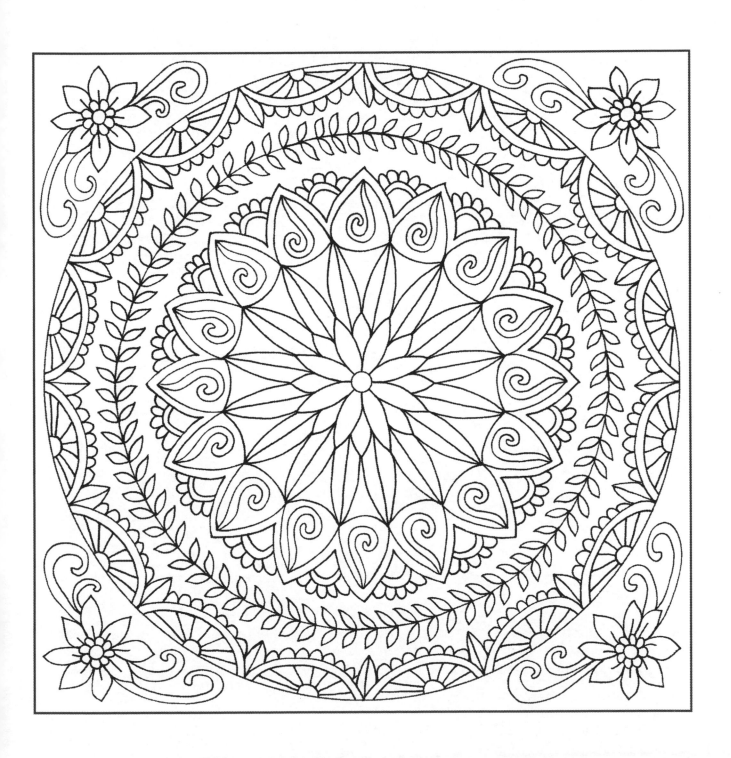

Mandala 06-04-16

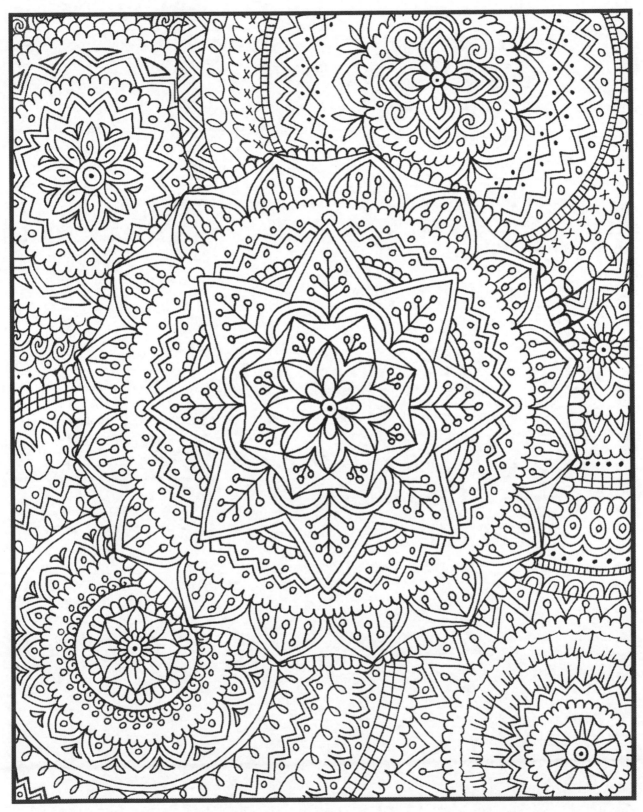

Mandala 06-10-16

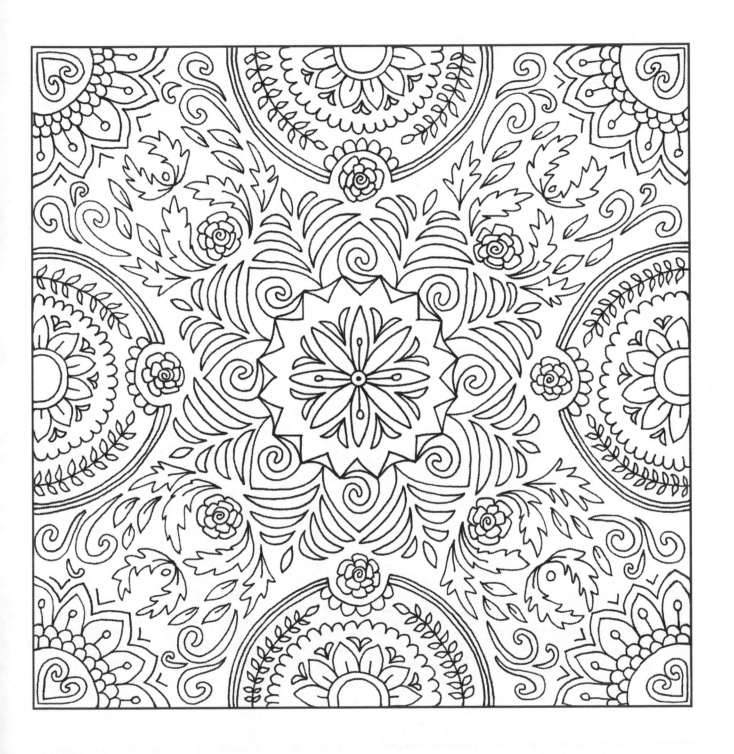

Mandala 06-11-16

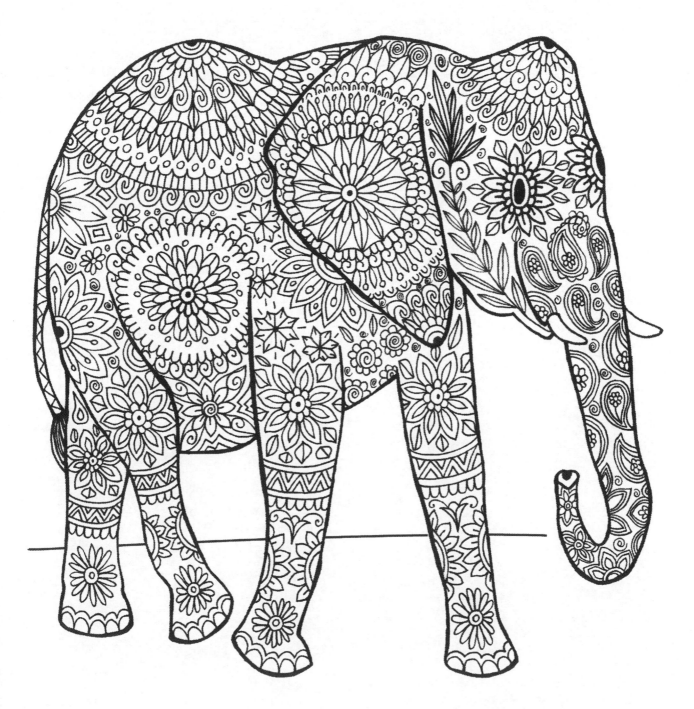

Mandala 06-21-16

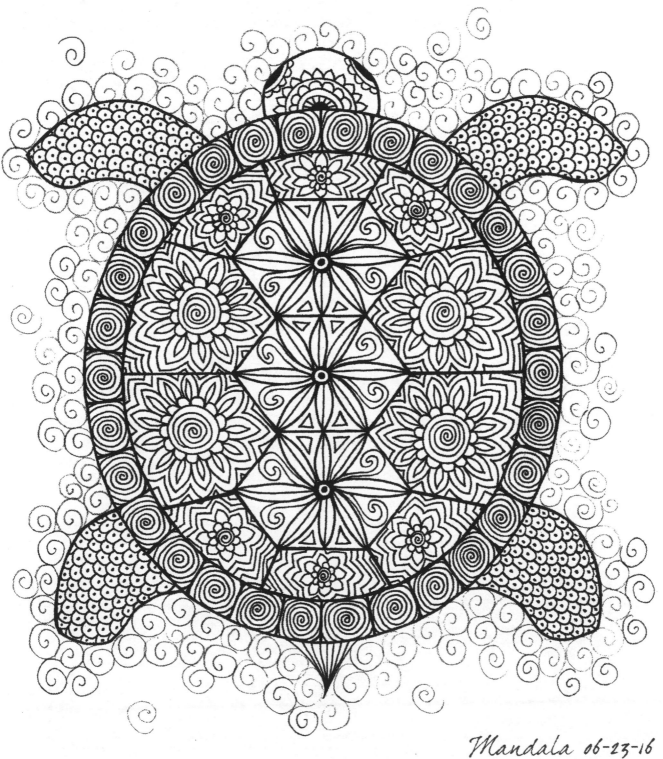

Mandala 06-23-16

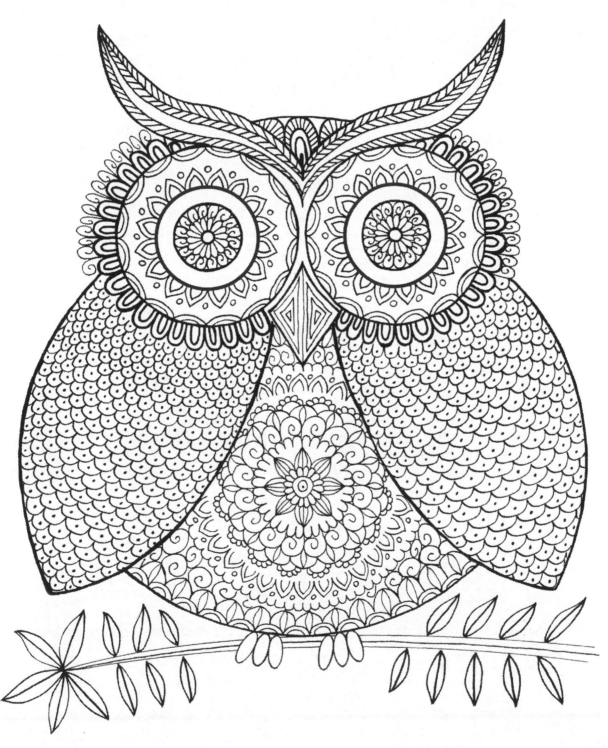

Mandala 06-24-16

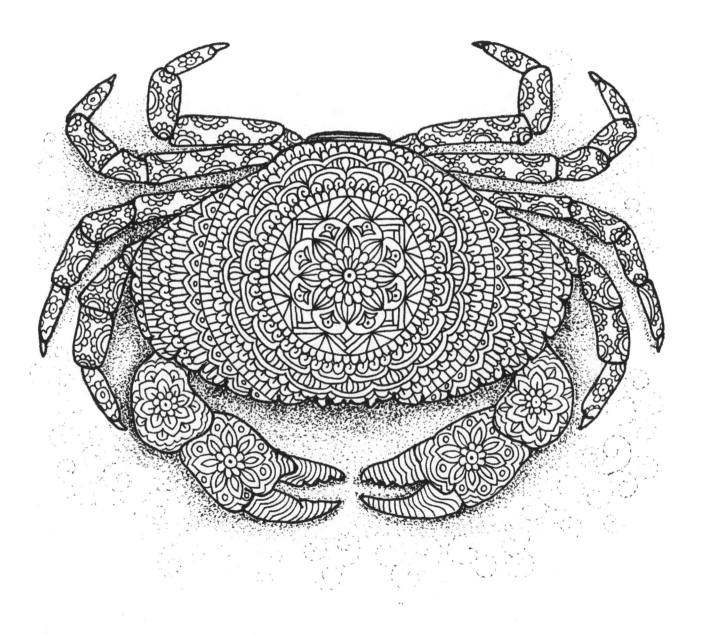

Mandala 06-28-16

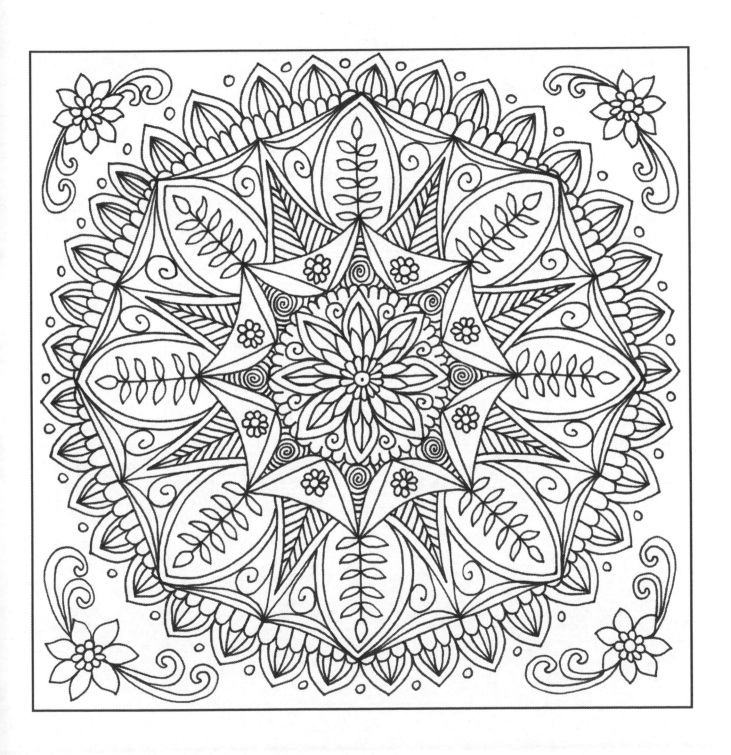

Mandala 07-08-16

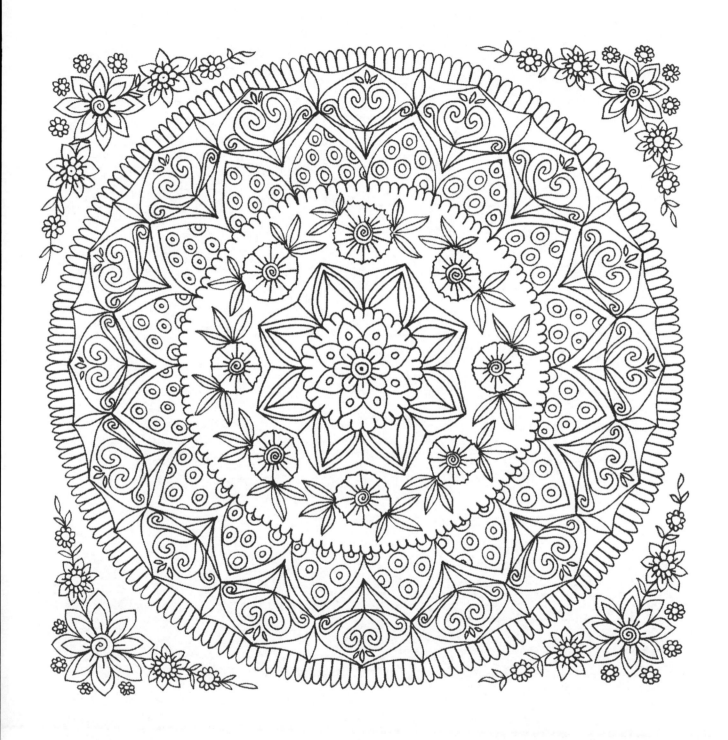

Mandala 07-17-16

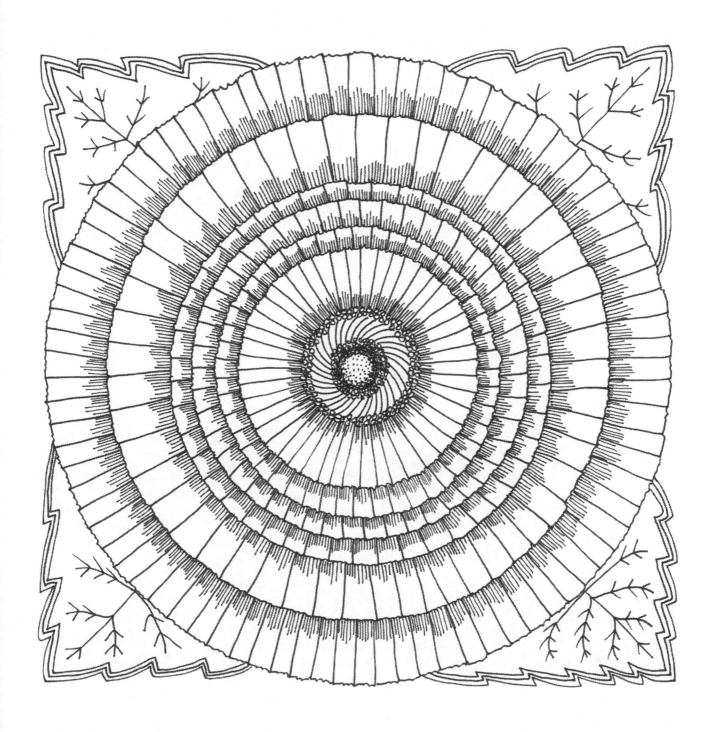

Mandala 08-21-16

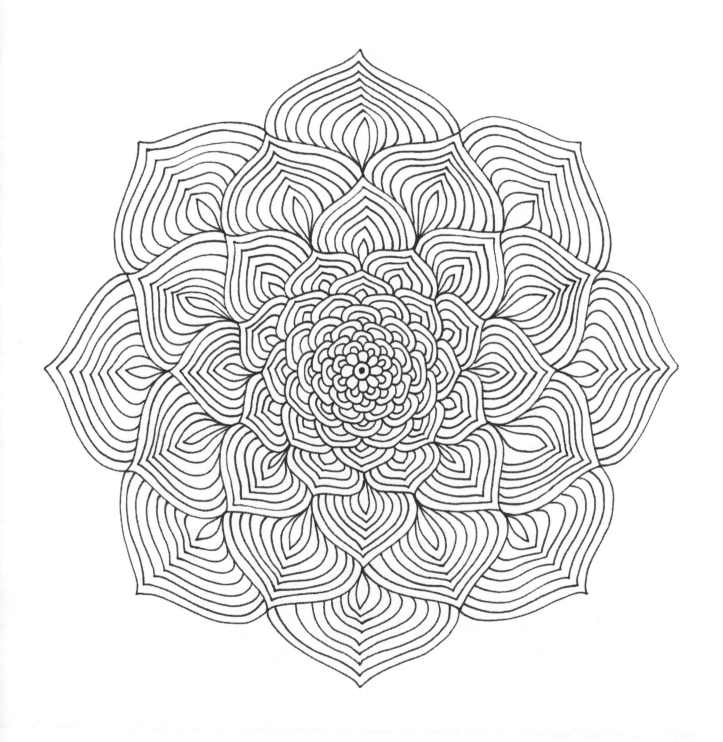

Mandala 08-22-16

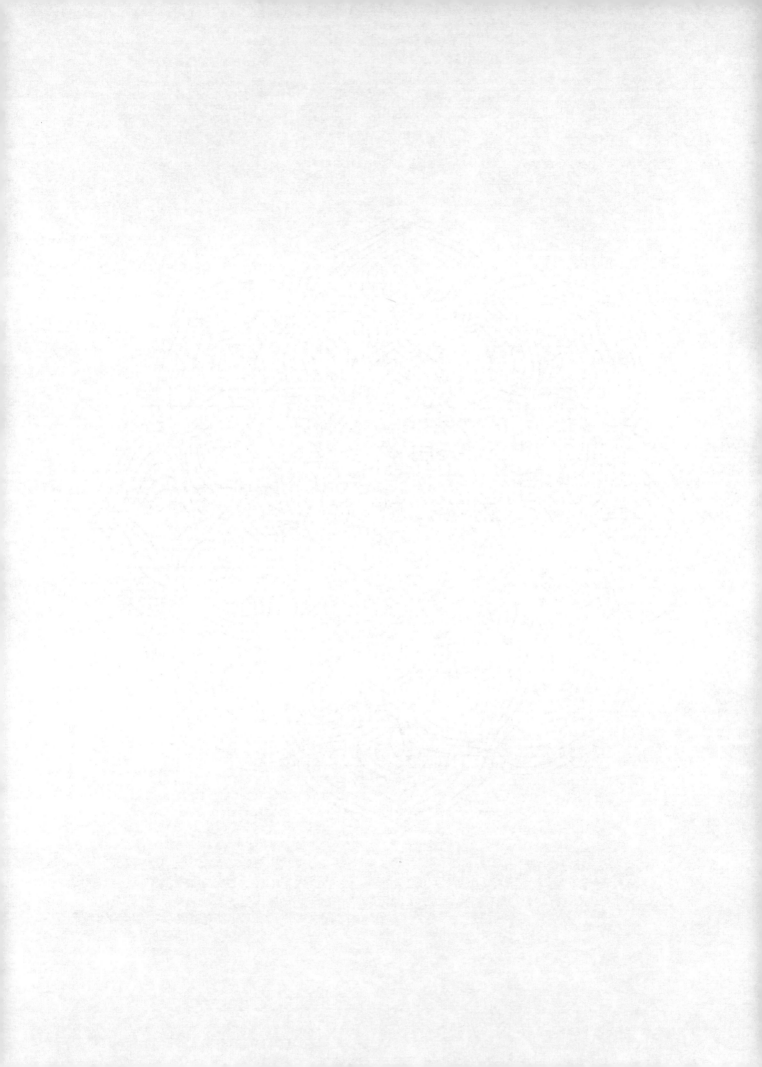

Mandala 08-27-16

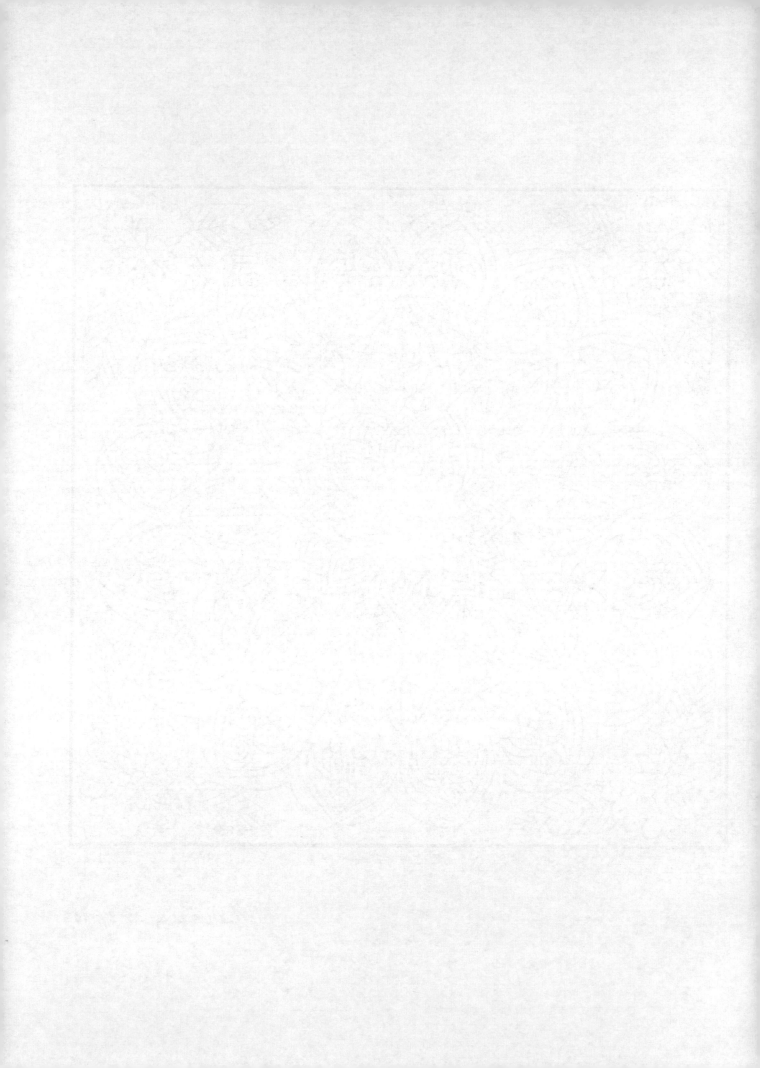

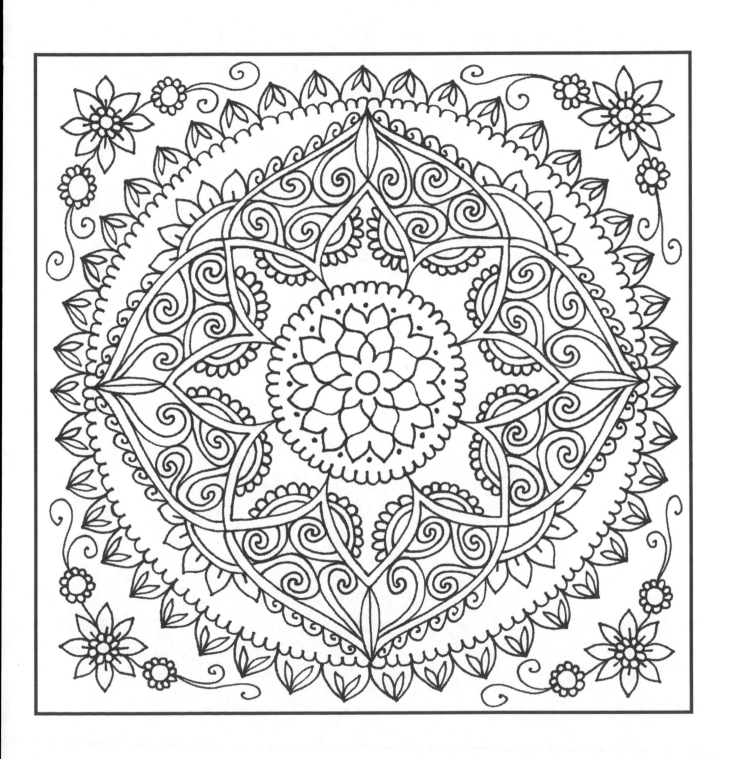

Mandala 08-30-16

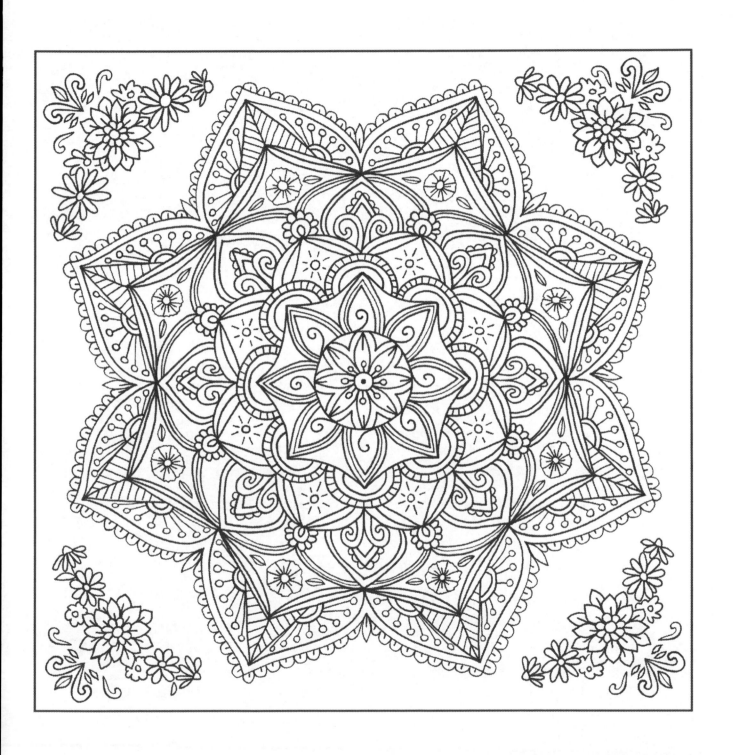

Mandala 09-23-16

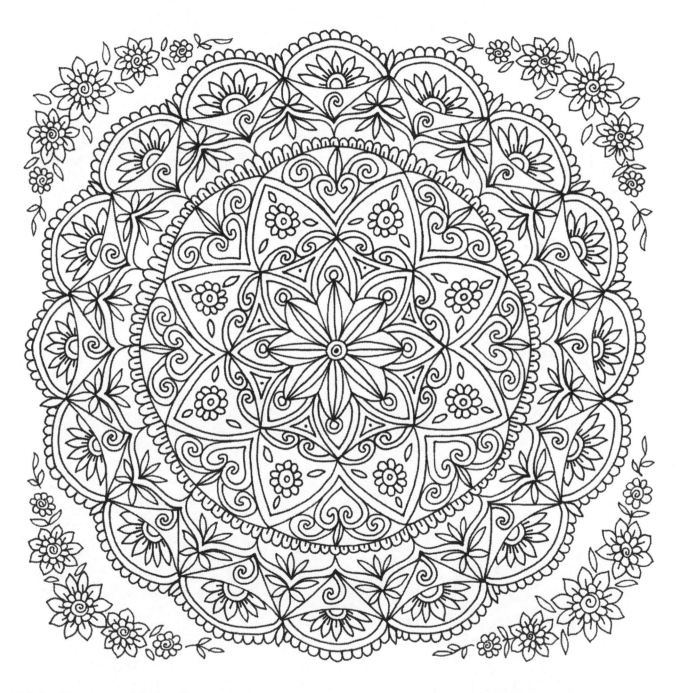

Mandala 10-08-16

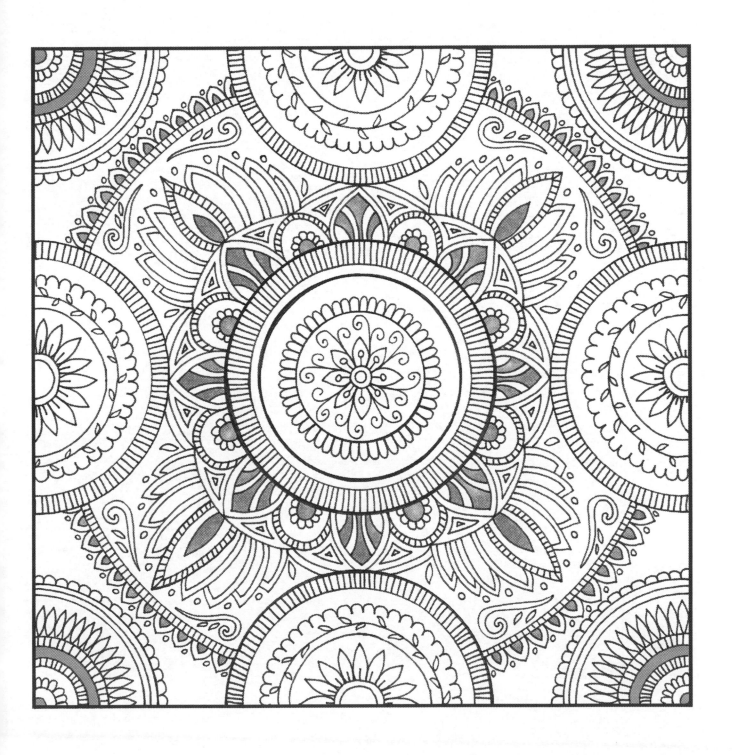

Mandala 10-11-16

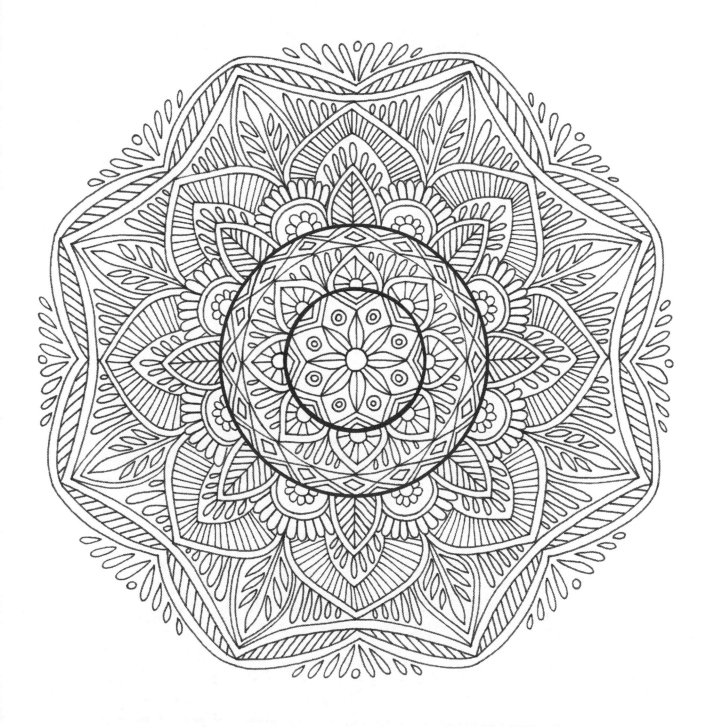

Mandala 10-12-16

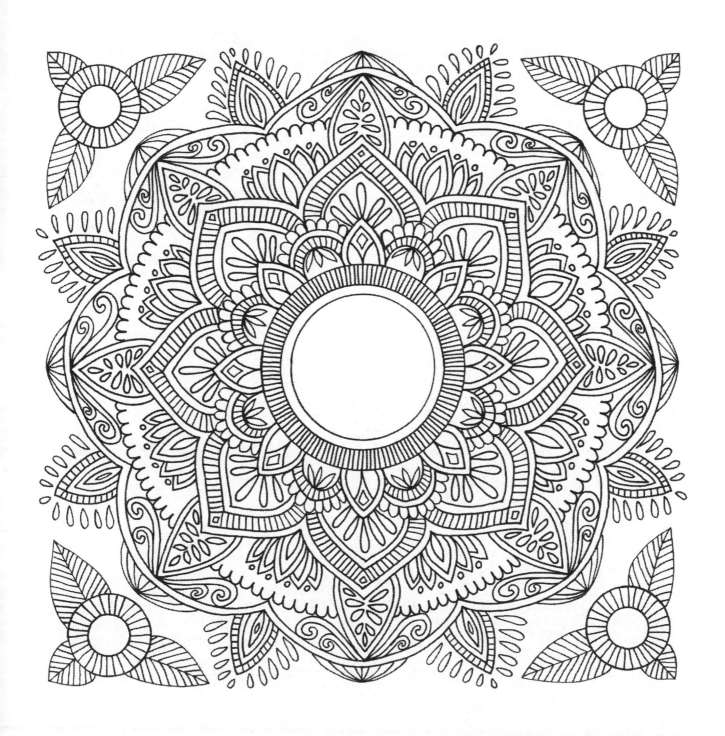

Mandala 10-13-16

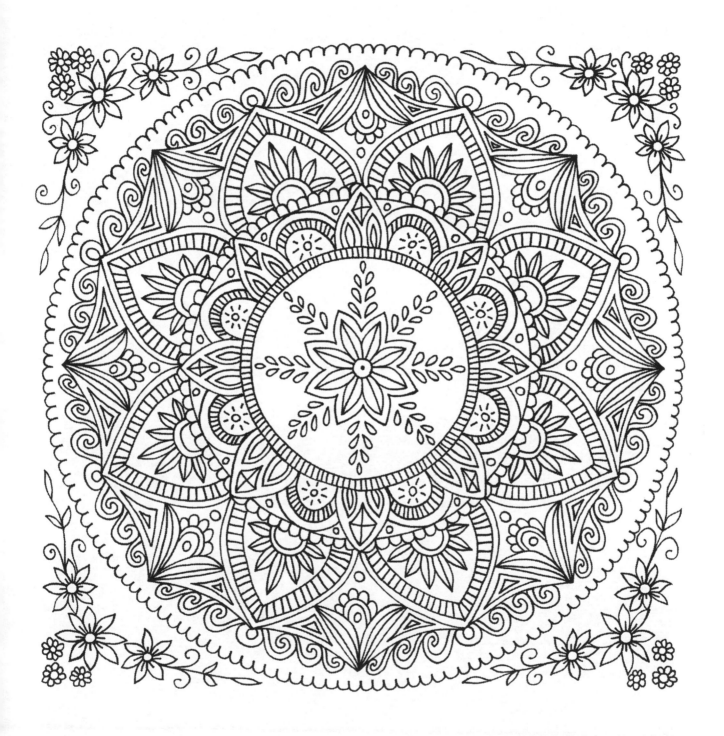

Mandala 12-27-16

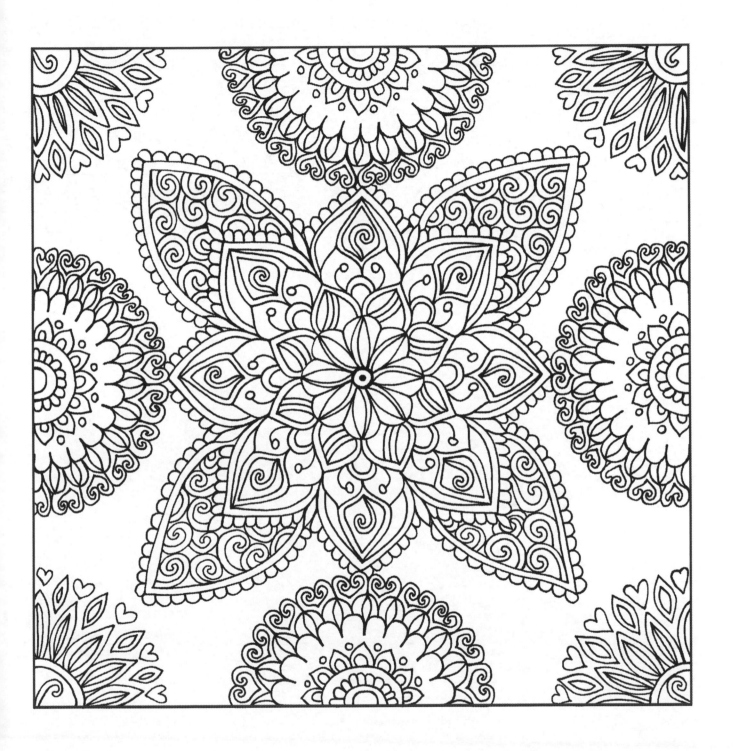

Mandala 01-15-17

About the Author

Jody Cooke earned her B.F.A in Textile Design from East Carolina University.
She later designed fabrics for Burlington Industries and Cone Mills in New York City.
She has also freelanced as a graphic designer and as a stained glass mosaic artist.
These artistic experiences culminate in her current focus designing mandalas.

Printed in the United States
By Bookmasters